VITAL

THREE CONTEMPORARY AFRICAN ARTISTS

FARID BELKAHIA

TOUHAMI ENNADRE

CYPRIEN TOKOUDAGBA

TATE GALLERY LIVERPOOL

africa95

The Trustees and Director of the
Tate Gallery are indebted to the following
for their generous support:

American Airlines
AIB Bank
Art Services Management
Arts Council of Great Britain
Australian Bicentennial Authority
Bacofoil
BMP DDB Needham
Barclays Bank Plc
The Baring Foundation
BASF
Beck's
David and Ruth Behrend Trust
The Blankstone Charitable Trust
The Boston Consulting Group
Ivor Braka Ltd
British Alcan Aluminium Plc
British Telecom
Business Sponsorship Incentive Scheme
Calouste Gulbenkian Foundation
Canadian High Commission, London and
The Government of Canada
Mr and Mrs Henry Cotton
The Cultural Relations Committee,
Department of Foreign Affairs, Ireland
English Estates
The Foundation for Sport and the Arts
Girobank
Goethe Institut, Manchester
Granada Business Services
Granada Television
The Henry Moore Foundation
The Henry Moore Sculpture Trust
Ian Short Partnership
IBM United Kingdom Trust
Ibstock Building Products Limited
ICI Chemicals and Polymers Ltd

The Laura Ashley Foundation
The Littlewoods Organisation
McCollister's Moving and Storage Inc
Manchester Airport
Manweb plc
Martinspeed Limited
Merseyside Development Corporation
Merseyside Task Force
Mobil Oil Company
Momart Plc
National Art Collections Fund
The National Heritage Arts Sponsorship Scheme
(Pairing Scheme)
National Westminster Bank Plc
North West Water Group PLC
NSK Bearings Europe Ltd
Patrons of New Art, Friends of the Tate Gallery
Pentagram Design Ltd
Pilkington plc
Pioneer High Fidelity (G.B.) Ltd
Royal Liver Assurance
J Ritblat Esq
David M Robinson Jewellery
Samsung Electronics
Save and Prosper
Seok-Nam Foundation
Stanley Thomas Johnson Foundation
Tate & Lyle PLC
Tate Gallery Foundation
Tate Friends Liverpool
Tate Gallery Publications
Unilever Plc
VideoLogic Ltd
Visiting Arts
Volkswagen

CONTENTS

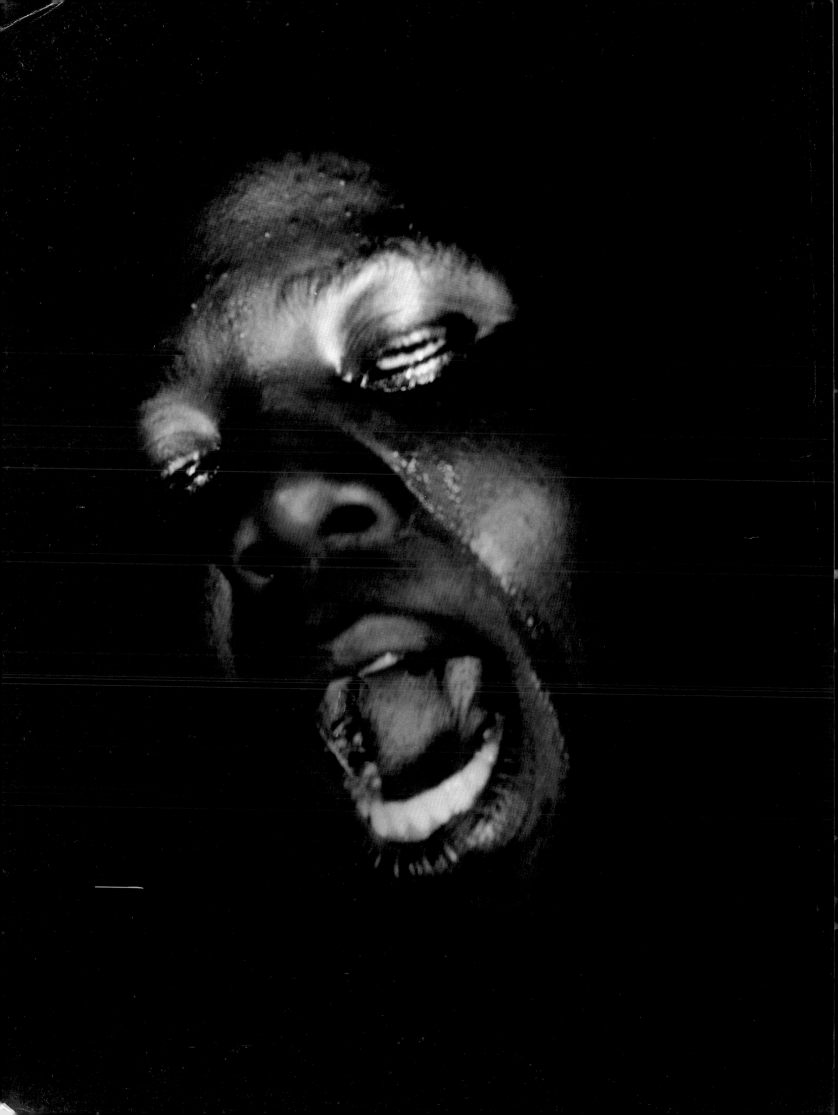

ART AND TRANCE
ABDELWAHAB MEDDEB

The originality of the African contribution to art lies undoubtedly in its relation to trance. So what, exactly, is trance? Trance is what makes its subjects go into a state of ravishment, in which they are transported, the better to return to themselves. This definition indicates the relation between trance and ecstasy. Ecstasy appears to belong to the venerable Western tradition of mysticism, in which the excess of the subject is embraced by divine love, which contains the metaphor of sexual jouissance, notably female jouissance. Saint Teresa of Avila remains the best example of this literary representation, one given exemplary illustration in the Baroque sculpture and painting of Catholic Europe. The Roman century that followed the Counter-Reformation offers a rich catalogue of swooning, ecstatic, languorous saints who appear to have been captured at the climax of orgasm.

I do not know if the Western tradition has formulated a technical distinction between trance and ecstasy, but I do know that the Islamic tradition has. Ecstasy (*wajd*) occurs in the context of an esoteric spirituality associated with the transcription of experience. The subject overflows, comes out of themselves and is projected into an imaginal, visionary space, yet at the same time has to look within themselves to find the ordering of the figures that make up the spectacle of spiritual vision. The very term ecstasy (*wajd*) is resonant with the sense of discovery, of invention, of a quest completed. As a term, it is almost equivalent to the 'Eureka' exclaimed by the scientist when the last veil is lifted on the path of research, and discovery appears in all its radiance in the mind's eye. In both cases there is the same jubilation and the same instantaneousness.

In contrast, trance (*jadhba*) is more passive. True, the word also points to a kind of movement outside the self. But in trance the subject finds nothing on their own. Here the precious kernel of being is attracted, almost magnetically, by an external power and energy. This movement outside the self proves refreshing, salutary and liberating. That is why trance is so often practised in conjunction with therapy: it frees the subject of any hampering excess. The scene of trance is associated with popular culture, it is considered as belonging to common man and not to some learned elite. Thus the rites surrounding it tend towards the spectacular, towards public display and the occupation of space at major gatherings and seasonal festivals.

In fact, when one considers the narrowness of the definition of the French word *transe* (which originally meant 'to be in a state of fearfulness or worry'), it is clear that the phenomenon of trance is alien to the Western spiritual tradition, in which the theme of rapture was represented only in the concept of ecstasy. Indeed, it was not until the end of the nineteenth century that the French language widened the meaning of '*transe*' to include transport, exaltation, rapture. This extension was, moreover, signalled by the adoption of the meaning of the English word 'trance', a technical term taken from the world of spiritism - a world in which intense existential energy was watered down into a parlour game. But this belated recognition of wider meaning does more than reveal the absence of the phenomenon in the culture embodied by the French language; it also shows how a society forges new definitions that correspond to the changing realities that language has to represent. Indeed, this new meaning emerged somewhat belatedly in relation to the descriptions of the trances witnessed by colonial travellers, writers and ethnographers. On countless occasions the French way of seeing found itself confronted with these scenes of excess which are as fascinating as they are terrifying. To look no further than North Africa, I am thinking of all those writers and painters who were present at the wild sessions of the convulsionaries from the redoubtable Aïssawa sect whose patron saint and founder is buried in Meknès.

It can be argued that the phenomenon of trance constitutes the unthought or repressed dimension of Western and European culture. It is clear that if one goes back to the classical tradition, to the seventeenth century French philosopher René Descartes, the excess that governs the scene of trance is explicitly foreclosed in the text of his *Discourse on Method*. Without going so far as to consider the idea of trance (which is excluded from representation), classical authority already reduces those who experience ecstasy to silence (this is one explanation of the tension between the Baroque aesthetic and classical taste, a tension inherent in European culture). Did not the classical French theologian and writer, Jacques Bénigne

Bossuet (1627-1704), hold that the unsayable cannot be the horizon towards which all discourse tends? And in his fight against quietism did he not thereby comply with the notion that ecstatics express themselves merely in shouts and groans, rather than mingling words with that which cannot be seen, spoken or heard?

But the European subject rebelled against this denial of trance, the denied representation of excess and transport. Looking at the genealogy of this revolt, we can see that it began with Romanticism. Its most radical theorist, however, was Friedrich Nietzsche. In *The Birth of Tragedy* the German poet-philosopher came up with an answer excavated from the very foundations of European culture, to correct this denial. He countered the Apollonian pole by reviving the Dionysian, whose theatrical presentation of the figures of excess, exaltation and ravishment make it the exact equivalent of trance.

In the twentieth century, with the advent of psychoanalysis and the subsequent popularisation of the notion of the unconscious, Western culture took a decisive step towards that point on which the energy of trance converges. It is no coincidence that this popularisation went hand in hand with the development of ethnology. The disciplines of psychoanalysis and ethnology were to be the vigilant companions of the great artistic revolutions that have occurred in the West this century. One need only recall the emergence of the idea of trance in Surrealism, in the work of Antonin Artaud (particularly *The Theatre and its Double*, in which he talks of wild theatre) and of Georges Bataille, whose emphasis on excess and liminal experiences constitutes an implicit polemic against Descartes' *Discourse on Method*. Not surprisingly, then, one of the places where African forms of representation emerged as an artistic yardstick was Bataille's review *Documents*, whose contributors included Giacometti. When all this took place, at the end of the twenties, the perceived distortions of African figurative art had already wrought their destructive effects on the Western canon.

This triumph of primitivism as part of the widening of the sources of Western creativity is, without doubt, related to the symbolics of trance. One proof of this is the text written by Jung in southern Tunisia in which he records the impact made on him by a session of convulsionaries. Indeed, that very evening, elements and figures of the session cropped up in his one of his dreams. The interpretation is clear: the scene of trance is associated with the unconscious because of its upsetting and unpleasant effect on 'civilised people', whom it makes uncomfortably aware of their continuing involvement in a primitive dimension which they have not expunged, merely repressed, and therefore cannot prevent from rising to the surface of their consciousness.

What are the roots and itineraries of the contemporary African artists whose work maintains a connection with trance? First of all, Farid Belkahia, Touhami Ennadre and Cyprien Tokoudagba do not all come from one and the same Africa. The eyes and hands of the first two were trained in Morocco, a country where trance is fed by two different cultural sources: on the one hand, a residual paganism derived no doubt from the ancient Dionysian structure of Mediterranean civilisations and, on the other, a more recent resonance of sub-Saharan Africa disseminated by black slaves, a phenomenon which permeated the country's borders until only a few decades ago. Furthermore, as an Islamic nation, Morocco has been receptive to echoes of the polemic sparked over mysticism in general and against its most spectacular form, trance, in particular. This polemic against mysticism and trance is both traditional and contemporary. In traditional terms, it is comparable to the premise of the Cartesian pole of reason. In the modern period through to the present, it is perceived as the locus of archaism and historical backwardness by reformists (*salafis*) and fundamentalists alike.

It can therefore be said that these artists come from a scene of resistance. In fact, they stand at a certain remove from the trance itself. They take up a position in relation to its fecund presence. Their relation to trance varies with their temperaments and the technical characteristics of their chosen media. Touhami Ennadre immerses himself in the scene of trance. His photographs capture the moments of this art of movement in close-up, so close indeed that the subject disappears. The movement of the photographer follows that of the dancers as they abandon themselves. The camera homes in on their black skin, its pearly gleam intensified by the work on shadow and

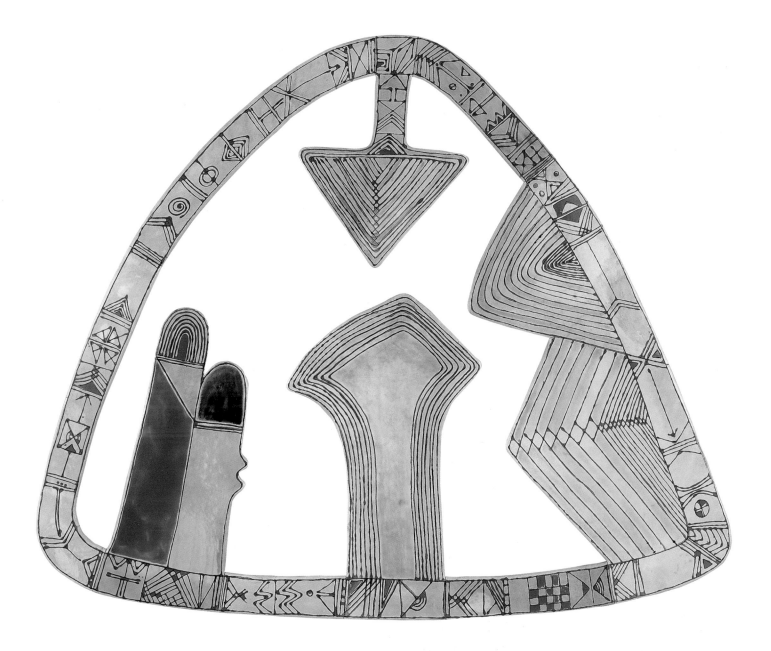

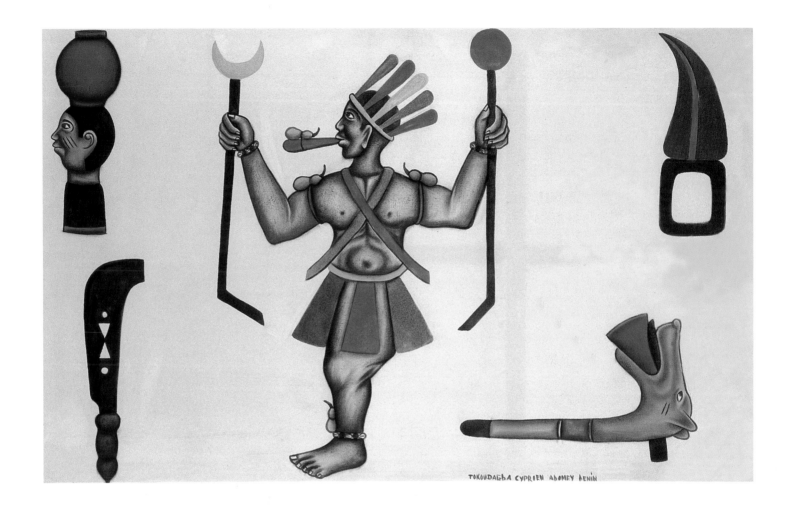

light in the darkroom. It is as if the poet had decided to forsake articulated words and to construct a poem using only the sonorous energy of onomatopoeia. Although Ennadre's work is at the heart of trance, the disappearance of the subject and the schematisation of his technique help create a certain detachment.

For Farid Belkahia, trance is simply a necessary memory; it haunts his mind as he transcribes the signs that accompany the discourse of trance, in a bodily posture that is closer to the sparing movements of the scribe than those of the soothsaying witch doctor. It is true that his recent human-sized works are founded on the twin principles of convulsion and distortion, and thus project the shadows of African totems and fetishes, but the signs marked on the skin always suggest the contained gestures of a man sitting cross-legged, calmly inscribing his autographs on a support that remains within easy reach.

It may be that Cyprien Tokoudagba has forgone the use of metaphor, for his images draw directly on the magic symbols of voodoo. We are told that the religious nature of Tokoudagba's art is confirmed by his use of a sacrificial rite to empower the creatures he exhibited in the Paris exhibition *Magiciens de la Terre* in 1989. Readers of mystical texts in any culture will know that the problem of the relation of the figure to the invisible raises problems that can shake a faith to its very foundations. Even the most fervent believers know that figures and images are no more than an intermediary to facilitate access, a passageway. And I do not think that the magic and enchantment of the work rests in Tokoudagba's African, Beninois origins. The very fact that the artist locates his images within the domain of modern art alters the nature of the work. It submits to this displacement, on one hand losing some of the enchantment due to belief and on the other, gaining another form of transcendence, one which comes from the consecration of the work as art.

It would be presumptuous to think that the relation these African artists have with trance is derived from the same procedures as those used by Western artists to accomplish their own revolutions, and liberations. Rather, the role of the Western world - which has become 'the world' *tout court* - is apparent in something much more basic: the relation these

artists have to their media: their use of the picture surface, their movement away from the temple and towards the hospitality of the museum. But the genealogy of vision, like any subjective phenomenon, necessarily differs from one culture to another.

If the West's debt to Africa is artistic, then perhaps Africa's debt to the West is ethical and political. The spectacular visual fecundity of trance will never suffice if it occurs within an economy of hereditary belief which subordinates the subject and perpetuates the reign of the chief and the priest. The phenomenon of trance keeps us in the realm of religion, and when it comes to religious matters we would prefer to follow Kant, in other words, to pursue freedom of choice and freedom of conscience. That is the paradox: for trance to fertilise art with its energy, the beliefs and thoughts of the subject and citizen must be free.

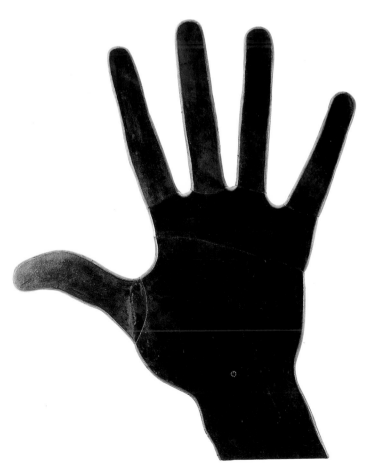

FARID BELKAHIA

TRADITION IS THE FUTURE OF MANKIND
RAJAE BENCHEMSI

Farid Belkahia often asserts that 'the most important thing for an artist is the ability to move on to something different'. One should not take this simply to mean a change of material or technique. What is required is a fundamental change of attitude, one which allows creativity to develop. Belkahia thinks of existence as a set of earthly forces which, through an intense communion with beings and things, evolve (hence the arrow) towards a kind of mystic plenitude, devoid of religious references. What follows is an account of Belkahia's own artistic development and the dynamics of change embodied in his art.

Beginnings

Born in Marrakech in 1934, Belkahia studied at the Ecole des Beaux-Arts in Paris between 1954 and 1959, before moving to Prague where he lived until 1962. There his work began to take its now characteristic form: already evident was the obsessive use of the circle and arrow which recur as a kind of personal insignia throughout his career. His interest in torture also dates from this period. He began to work in an expressionist vein, bearing witness both to the dreadful violence of the French prisons during the Algerian War of Independence and to the horror engraved in the walls of the 'corridors of death' at Auschwitz, which he had seen in 1955. In 1962, Belkahia returned to Morocco, where he was made Director of the art school in Casablanca. Here he worked hard to institute a liberal teaching system, whilst ensuring that his students were spared the pressure he had suffered in the studios of the Beaux-Arts. His keen interest in memory, and in the human evolution expressed in tradition, led him to set up workshops on the history of Moroccan craftsmanship, from carpet-making and silver jewellery to ceramics and pottery.

New materials: copper

'One can only be aware of modernity,' Belkahia insists, 'if one has assimilated the old values'. In this spirit he organised the first street exhibition in Marrakech, setting out works of art in a public square, the aim of which was 'to enable two worlds of thought that never have the chance to meet to come together'. But the popular success of the event made the Moroccan authorities increasingly reluctant to allow others. Belkahia devoted himself to the development of the art school and stopped working with oils and paper to experiment with a traditional Moroccan material, copper.

For Belkahia this sacred material - the red or yellow copper leaf which he folded or hammered, moulded and mounted on wood - allowed a passionate, exultant engagement in which hand-wrought folds and twists burst from voluptuous and fragmentary female bodies. It was, he said, 'a salutary experience', as if the physical work on a material both malleable and hard allowed him to begin a process of sublimation which, without the slightest guilt, would lead him away from the traditional Western techniques of oils and easel painting. Belkahia never went back to them. His moulded, as opposed to sculpted, copper forms break out of the traditional frame of the rectangle and square, propelling into space strange and dynamic forms from which the body thrusts forward, charged with an amorous tension that one imagines is the legacy of the painter. After twelve years of working on copper and, coincidentally, just as he was deciding to leave the art school in Casablanca, Belkahia began experimenting with another traditional material: animal hides.

Hide

Hide is close both to the body and to the sacred. It is used raw: washed, treated, dried in the shade and stretched on prepared wooden forms. Its physical composition imposes a number of constraints. First of all, it necessitates the exclusive use of natural dyes such as henna, which gives a rich range of reds and browns; saffron and pomegranate bark for yellow; cobalt, whose colours go from purple to black, and yamo, which provides a range of blues. Belkahia's ochres - browns, reds and yellows - are not the result of a purely artistic decision, but are in harmony with the artist's desire to stay as close as possible to the colours of the earth. Such materials inevitably evoke the traditional techniques of parchment-making and tattooing, but Belkahia's use of it obliges us to suspend this reference and think instead in terms of a thoroughly unequivocal modernism.

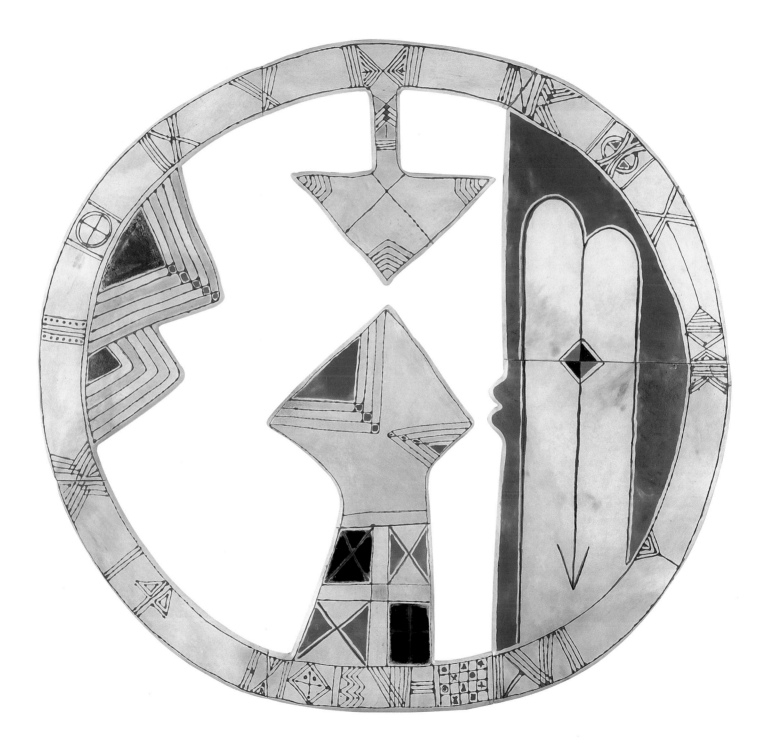

While the borrowing from tradition naturally implies an act of memory, it is nonetheless true that Belkahia's work is founded on a long process on forgetting. Hide, as a medium, is akin to parchment with its recessive properties, not as a palimpsest, carrying the traces of another time and other skills, but as a disappearance and 'making absent'. This disappearance leaves a new space where the very act of recollection is experienced as original creation, its only relation to memory being its capacity for forgetting. As a frontier between interiority and exteriority, the washed hide becomes a symbolic expanse, a place where hope is marked and designated. Rescued from putrefaction, it makes death recede and sends back our gaze, from alienation to the past.

From Procession to Trance

'Each individual', argues Belkahia, 'is locked into a circle, a sort of personal cosmos where we are subject to pressure from every direction, pressure that is liberated by trance'. The recent series of circular paintings (included in this exhibition) issue forth from a black mass in which the void left by the movement of the arrows and triangular forms struggles with the essentiality of the circle. Meaning, or the reading of the meaning, is formless and total, as if to intensify the emergence of dream. Freighted with symbolic signs and characters from the *tifinagh* (Berber alphabet) and contained within the primordial form of the circle, the arrows direct our gaze towards an obvious duality: up and down, movement and immobility, life and death. Everything in this work seems to emanate from a zone of silence, a captive silence where being is apprehended in its most absolute complexity, a written silence, as in music, working towards the general harmonisation of manifestly paradoxical forms and forces.

Belkahia's interest in trance comes from many hours spent listening to the sacred music of *gnawa*, that of the Africans who came to Morocco from the banks of the Niger and Senegal at the end of the sixteenth century, adopting Islam and joining Morocco's religious brotherhoods. Trance interests him as a physical phenomenon, but also philosophically: 'If you watch the dance, the movement that at first seems anarchic gradually takes on a structure based on the form of the triangle and then

that of the circle. What also interests me about *gnawa* is that the forces of evil and good both move towards the same centre of energy and cohabit, just as in life there is a set of conflicting forces. In *gnawa* ritual, each of these forces is represented by a given colour (yellow, green, black or white). They are supposed to combine and, through the developing abstraction of the trance, lead the subject to a state of ecstasy, the ultimate locus of creation, and of spirituality, if we can conceive of spirituality outside the framework of religion'. For Belkahia, the idea of the procession is itself an expression of opposing forces, for 'each individual is himself a crowd'.

Jerusalem

In 'Jerusalem' 1994-5, phallic forms rise up towards a strangely blue and pure sky, as if to lash it with their strength, as if to penetrate the mystery that lacerates the town. 'The fabulous thing in Jerusalem', says Belkahia, 'is this acute awareness of man's responsibility before time, and the extraordinary feeling one has of wandering in the maze of memory'. As these words indicate, this work is anything but a political statement. It is a new hymn to memory, to the need to move forward, starting from the knowledge that lies deep within us, and which guides our consciousness. After a week-long stay in 1958, Belkahia went back to Jerusalem in 1994 and experienced the same, powerful emotions in this great palimpsest of a town where everything is organised in strata, where convulsive memory is crystallised in a quest through the centuries for a smell, a face, that could give form to the elusive hope that haunts it. Farid Belkahia has said that, 'Drawing is to painting what words are to poetry'. I would add that Jerusalem is to memory what words are to poetry.

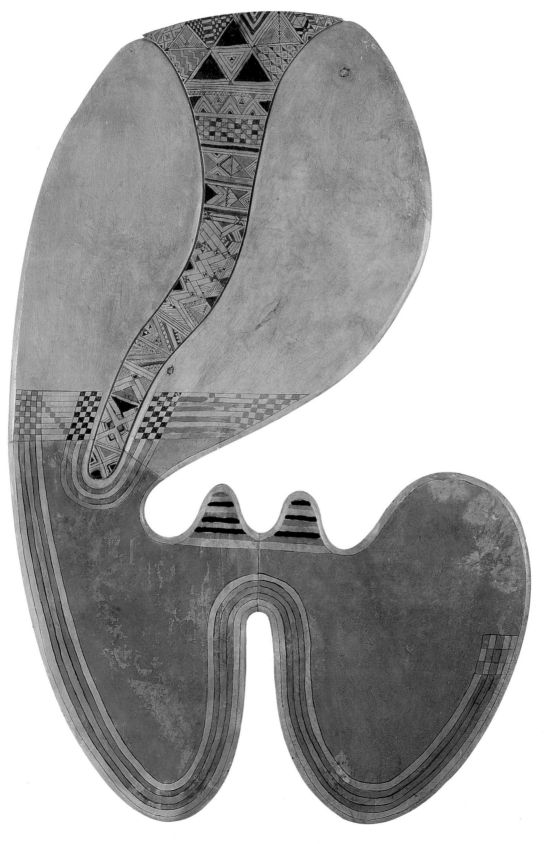

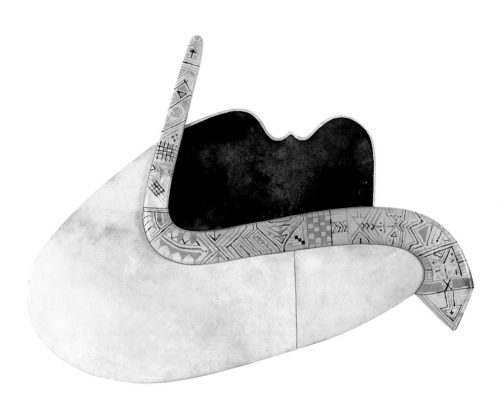

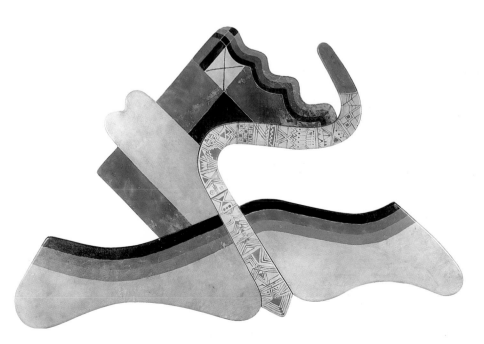

17

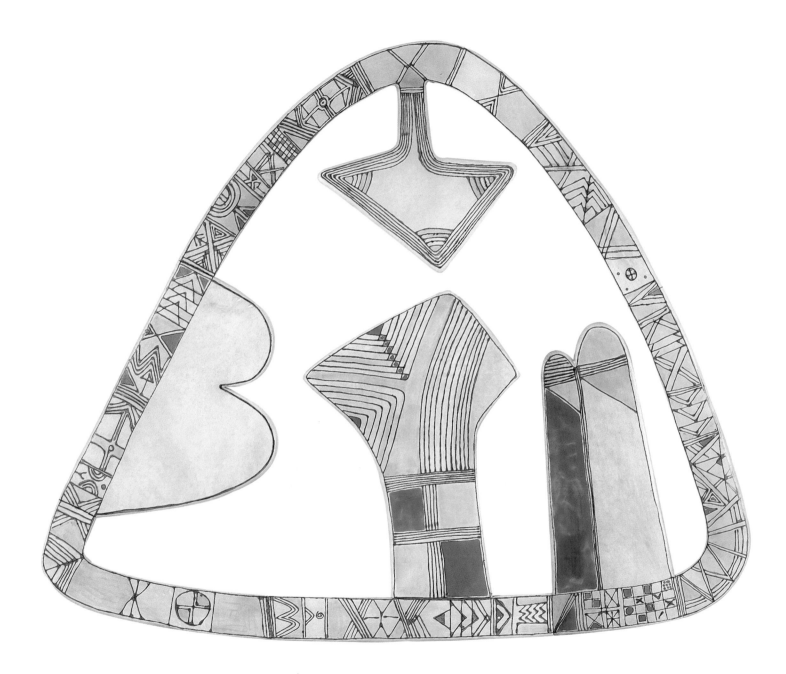

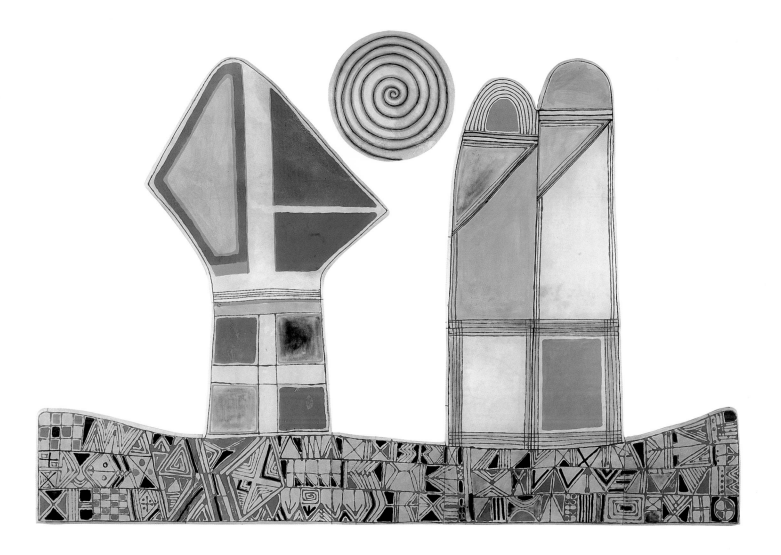

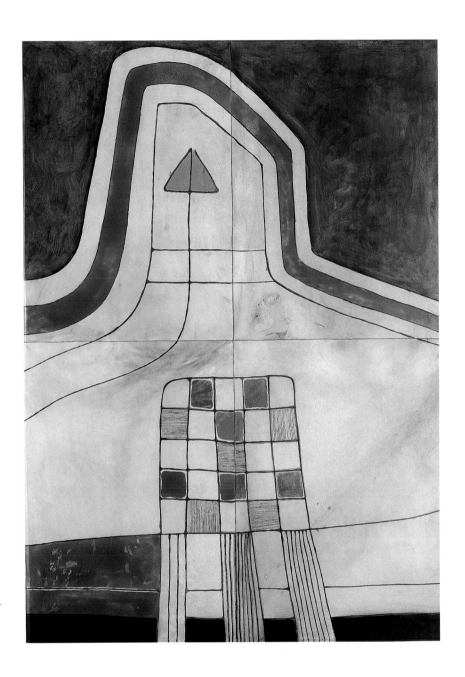

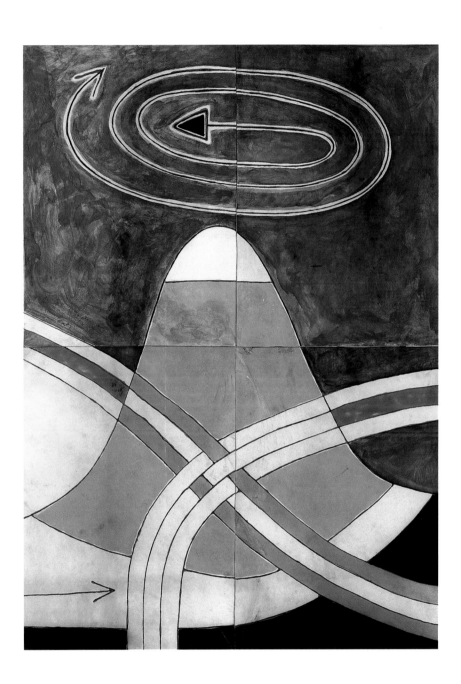

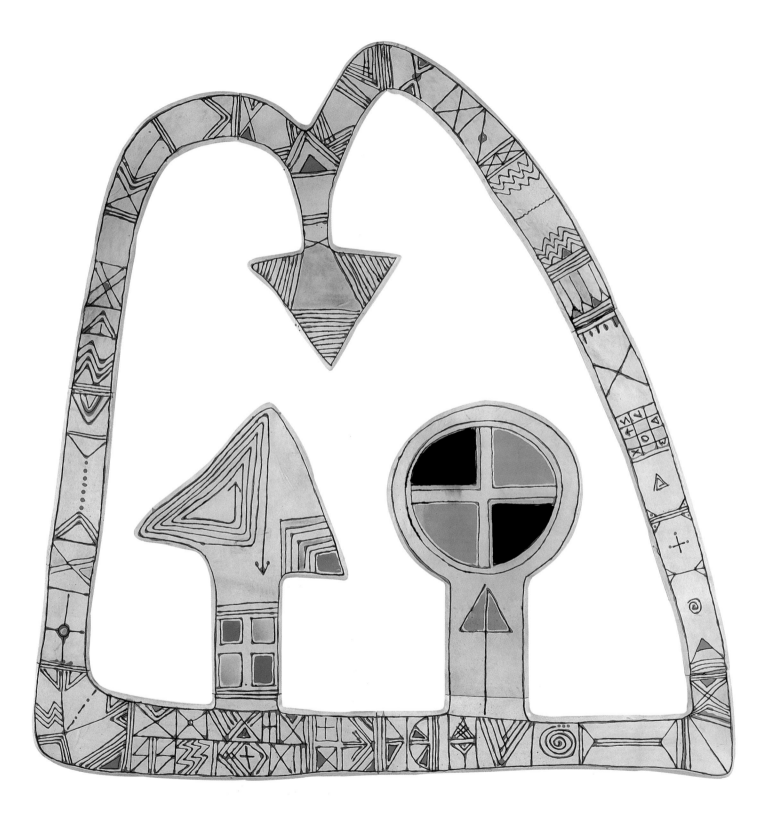

FARID BELKAHIA

Biography

1934	Born Marrakech
1955-9	Ecole des Beaux-Arts, Paris
1959-62	Institut du Théâtre, Prague
1962-74	Director of Ecole des Beaux-Arts, Casablanca
1965-6	Academia Brera, Milano

Solo Exhibitions

1972	Galerie l' Atelier, Rabat
	Galerie Design Steel, Paris
1977	Galerie l'Atelier, Rabat
	Galerie Structures BS, Rabat
1979	Moussem Culturel d'Asilah
1980	Galerie Documenta, Copenhagen
	Galerie Nadar, Casablanca
1984	Galerie l'Atelier, Rabat
	Musée Al Batha, Fès
	Centro Culturel Espagnol, Fès
1986	Maison de la Culture du Havre, le Havre
1990	Galerie Erval, Paris
1992	Galerie Erval, Paris
1993	Galerie Al Manar, Casablanca
1995	Galerie Darat Al Founun, Amman

Selected Group Exhibitions

1956-9	Alexandria Biennale
1957-59-61	Paris Biennale
1957	*Peintres Marocains*, Tunis
1958	*Arts Plastiques Marocains,* Washington
1963	*2000 ans d'art au Maroc*, Paris
1966	*Festival des Arts Nègres*, Dakar
1969	*Exposition manifeste*, Place Jamaa El Fna, Marrakech
1974	Peintres Maghrèbins, Algiers
	Ist Arab Biennale, Baghdad
1977	Galerie l'Atelier, Rabat
1978	*Peintures Arabes*, Iraqi Cultural Centre, London
1980	Salon de Mai, Paris
	Peinture Contemporaine Marocaine, Fondation Joan Miró, Barcelona
1985	*Présences artistiques du Maroc,* Musée de Grenoble, Grenoble
1987	São Paulo Biennal
1988	*Peinture Contemporaine Marocaine*, Musée de Ixelles, Brussels; travelled to Ostende and Liège
1991	Galerie Ipso, Brussels
	Peintures du Maroc: Belkahia, Bellamine, Chekaoui, Kasimi, Institut du Monde Arabe, Paris
1992	*Dessins*, Galerie Al Manar, Casablanca
1993	*Peintres du Maghreb*, touring exhibition in Spain and Belgium
1994	*Rencontres Africaines*, Institut du Monde Arabe, Paris; travelled to Johannesburg and Le Cap
1995	*Sculpture pour le cinquantenaire des NU*, Geneva
	VITAL: Three contemporary African artists, Tate Gallery Liverpool, Liverpool

Bibliography

Farid Belkahia, Maison de la Culture du Havre, Le Havre/ Institut du Monde Arabe, Paris, 1986

Peintres du Maroc, Institut du Monde Arabe, Paris, 1991

Peinture et Mecenat: une collection marocaine, Banque Commerciale du Maroc, Casablanca, 1992

Revue Noire, no 12, March-April-May 1994, pp 8-11

Rencontres Africaines, Institut du Monde Arabe, Paris, 1994

VITAL: Three contemporary African artists, Tate Gallery Liverpool, Liverpool, 1995

List of works

Hand 1980
skin, wood, pigment
125 x 152 cm

Hand 1980
skin, wood, pigment
125 x 152 cm

Divinity 1980
skin, wood, pigment
118 x 175 cm

Trance 1986
skin, wood, pigment
133 x 208 cm

Untitled 1986
skin, wood, pigment
157 x 120

Procession1 1994-5
skin, wood, pigment
176 x 217 cm

Procession 2 1994-5
skin, wood, pigment
177 x 210 cm

Procession 3 1994-5
skin, wood, pigment
179 x 219 cm

Procession 4 1994-5
skin, wood, pigment
170 x 182 cm

Procession 5 1994-5
skin, wood, pigment
164 x 255 cm

Procession 6 1994-5
skin, wood, pigment
182 x 178 cm

Procession 7 1994-5
skin, wood, pigment
143cm x 184cm

Procession 8 1994-5
skin, wood, pigment
191 x 208 cm

Jerusalem 1994-5
skin, wood, pigment
5 panels, each 176 x 127cm

All works are collection of the artist

TOUHAMI ENNADRE

TOUHAMI ENNADRE: THE TRACE OF TIME
NANCY SPECTOR

In his expansive, nocturnal photographs, Touhami Ennadre maps the uneasy dialectic between the living and the dead, a relationship that is forever circulating through (and informing) consciousness itself. His imposing, jet-black pictures function as modern-day emblems for the violence found at the core of human existence. They stand in silent testimony to the ravages of time that exhaust the aging body, the corporeal rupture that constitutes birth, the willful acts of savagery that deplete whole populations, the perpetual layering of the ages that physically chronicles the natural world. Ennadre's penetrating vision betrays a collective cultural 'guilt'; it quietly reveals the brutality underlying all forms of being. The work, however, is not moralistic in the conventional sense. Scenes of childbirth and slaughter, for instance, are presented as equivalents; the same black luminescence pervades and defines images of both themes. The immense scale of Ennadre's photographs - not quite life-size, but emulative of it - endows each of his subjects with a similar feeling of gravity and profundity. The lustrous black tonality of the entire oeuvre lends an elegance to even the most sombre of pictures. Ennadre's aesthetic strategy is not one of reduction, however. Rather, he takes a consistent conceptual approach, from picture to picture and theme to theme, in order to underscore the subtle equation between life and death that informs the very essence of his oeuvre.

There is a meticulous typology in Ennadre's work. He photographs exclusively in series classified by subject or concept, though the number of pictures in one series may differ from that of another. This approach bespeaks his need to methodically record the variations of a single theme. When viewed collectively (as an archive) Ennadre's photographs chart ontological territories: birth, age, time, remembrance, suffering, death. Even a partial listing of Ennadre's different series conveys the depth and scope of his research and the existential tenor of his project. In 1982, for instance, he photographed deliveries in a maternity ward at the Hotel-Dieu hospital in Paris, capturing on film the moment of birth - a beginning that undeniably marks the initiation of aging. This series was followed by one devoted to the documentation of slaughterhouses in Stockholm, Munich, and Marrakech from 1983 to 1985. These are not architectural photographs, but rather excruciatingly close-up views of animal carcasses destined to be meat. The clusters of truncated animal parts and flayed cross-sections of animal flesh appear almost abstract, like sculptural studies in black and white. Yet, in their unsparing portrayal of carnage and their spectral silence, these images render death incarnate.[1] Similarly, photographs of sea creatures pulled from their natural environment in the series 'Fish and Octopuses' 1992-3, rehearse the theme of annihilation. Piles of just-caught fish, intertwined and still writhing, are pictured in the process of asphyxiation. In the larger context of Ennadre's typology, this series can also be interpreted as an allusion to the circular nature of life; after all, the genesis of all forms of life, including our own, occurred within the ocean depths.

Another series created in 1992 brought Ennadre to Poland, where he documented the haunted remains of Auschwitz. Again focusing on the specific detail rather than the totality of a given situation, he photographed suitcases confiscated from death camp prisoners, which were inscribed with dates, numerical codes, and ethnic labels: 'Juden', 'Pollak' etc. Neither editorial commentary nor accompanying captions are necessary; Ennadre's clarity of vision and economy of formal means alone invoke the chilling realisation that this luggage had once belonged to specific individuals and that it had reached its final destination. These photographs attest to the power of the mundane to reinforce the profound horror associated with the Holocaust and, for that matter, any act of genocide.

For Ennadre, photographic 'technique is not important, it's at most a means'.[2] Having had no formal training in photography, he developed a highly original working method, one which obscures as much of the subject as it reveals, a strategy that stresses the optical process as much as it does the object of vision. Ennadre uses a Hasselblad camera, to which he attaches two electric torches (one on the top and one on the bottom edge), the lights from which converge at a point halfway between the centre of the subject and the camera lens itself. His goal in employing this unusual form of illumination is to control or banish any unwanted shadows in the resulting picture. Subjects are photographed with a wide-angle lens at extremely close range, thus ridding the image of any illusion of

depth. The resulting spatial distortions and calculated flattening of the picture are corrected during the printing and enlargement process, when Ennadre manipulates test proofs, adding relief and light at various stages. At this point he also also masks out all background information, relegating everything but the most central, iconic image to utter blackness. The effect is comparable to a silhouette in reverse: peripheral details are obliterated by darkness, while the isolated subject seems to loom from the shadows, illuminated by some unknown, internal source.

The silhouette-like quality of Ennadre's images has a provocative etymological resonance that suggests a deeper reading of his project. The derivation of the English usage of the word 'silhouette' is from the French term 'portrait à la silhouette', which in turn is from 'silhouette' meaning '(an) object intentionally marred or made incomplete, something of ephemeral value'.[3] This reference to the transitory (made to define a form of representation) further accentuates the allusions to death in Ennadre's art and their correspondence to the photographic act itself. It has long been established that photography, as an aesthetic practice or a form of documentation, has connotations extending well beyond the biographical, the factual, or the creative. An instantaneous seizing of a subject from the empirical world and the subsequent isolation of it in a separate realm defined by stasis and silence, photography, in all its forms, is inextricably linked with death. As Susan Sontag observes:

> All photographs are memento mori. To take a photograph is to participate in another person's (or thing's) mortality, vulnerability, mutability. Precisely by slicing out this moment and freezing it all, all photographs testify to time's relentless melt.[4]

Such an observation has been most poignantly articulated in Roland Barthes's meditation on photography *Camera Lucida*. For Barthes, 'the return of the dead' endures in every photograph, each of which is an irreversible reminder that whatever was documented by the camera no longer exists in the state depicted; the moment rendered is forever lost, save for a fading two-dimensional image.[5] In this way, the photograph coldly and cruelly records what has already been lost to time,

while simultaneously capturing what will, eventually, be lost again - in death.

Touhami Ennadre's fixation on mortality (particularly as it is manifest in the photographic process) parallels that of Barthes, whose musings on the relationship between photography and death were prompted by a childhood snapshot of his dead mother. Ennadre's earliest experiments with a camera, in the mid-1970s in Paris, date from the time of his mother's death (his family having emigrated from Morocco ten years earlier). Upon learning of her fatal illness, Ennadre's impulse was to document her fleeting presence, to inscribe her memory photographically. For Ennadre, the death of his mother became inextricably linked to his pursuit of photography and his poetic use of the medium. As he explains:

> I've always been escorted by my past, my solitude, and what I've lived through. It's idiotic, but I can never talk about my work without talking about my mother, because I come from someone. I was a witness to her life, and my work is simply a kind of witness to this person I once knew.[6]

Ennadre's first exhibited series 'The Hands, the Back, the Feet' 1978-82, evolved out of the pictures he took at his mother's funeral in Casablanca. Rather than photographing the faces of his relatives and friends to capture expressions of bereavement, he focused his camera on their hands, the gestures of which communicated their grief in the most succinct and candid manner. Using this synecdochical formula during subsequent travels in Asia, Ennadre photographed, at very close range, the hands, feet, and backs of individuals whose aged, weathered skin recounts a multitude of personal sagas. Palimpset-like, the wrinkled and contorted bodies disclose the burdens and joys of a life fully lived. Though anonymous (all that we see are lone extremities floating forward from the shadows) these corporeal fragments bear the vestiges of years forever lost; they testify to what has been.

The physical trace, as a sign for what has previously transpired, as a record of things past, reverberates throughout Ennadre's work. In many ways, the theoretical implications of the 'trace' constitute the very core of his photographic project. As a form of visual signification, photography can be comprehended in semiotic terms as part of a larger practice

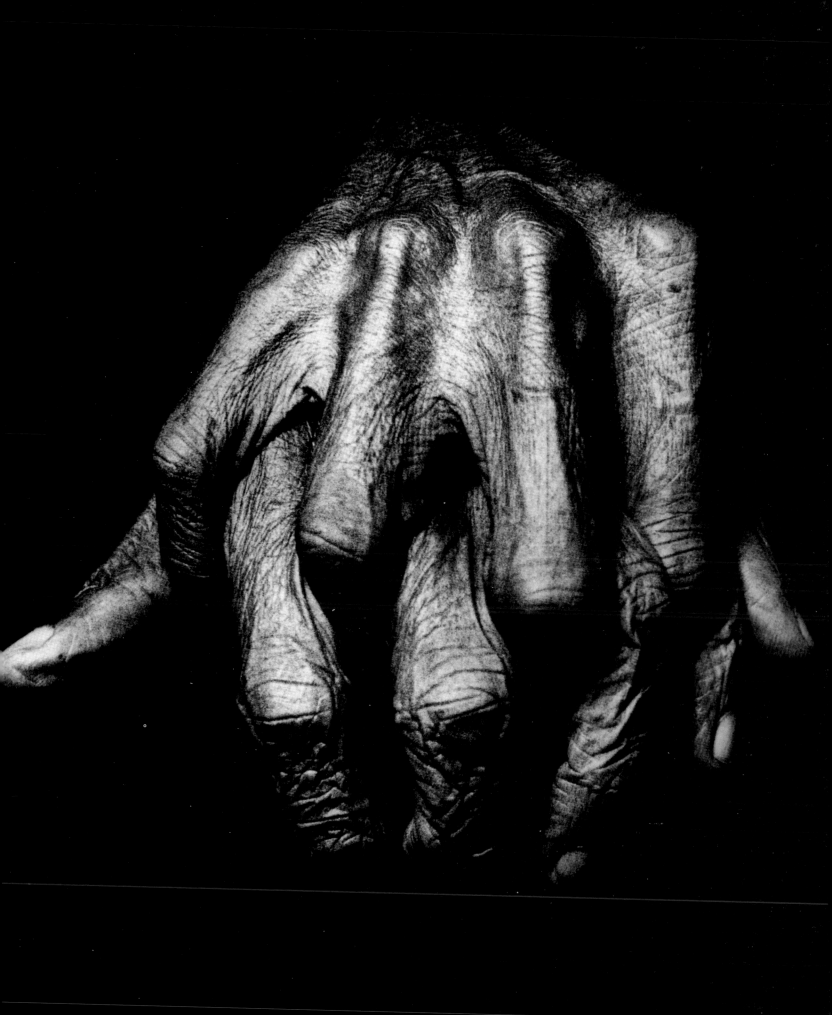

through which meaning is generated and conveyed. Because of its mimetic capabilities - its ability to render a seeming likeness of the perceived world - photography operates in an iconic mode. In other words, the photograph replicates its subject and thus conceptually (re)presents this subject in the subject's absence. In this context, the medium differs little from figurative painting and sculpture that seeks to simulate reality. But, due to its unique technology, the photograph also functions as an indexical sign.

The 'indexical' was defined by the American positivist philosopher Charles Sanders Peirce as a process of signification in which the signifier is bound to the referent by an explicit and contiguous connection to the empirical world.[7] An index is, thus, the physical mark or trace of a certain entity or event, which, in turn, becomes the sign for that entity or event. The index can take many visible forms; scars for a wound; lightning for a storm; footprints for one's passage; and cast shadows for one's presence, to name only a few and various instances.

Within the photographic model, the trace of the visible world is physically imprinted by light as it interacts with chemicals on photosensitive paper. The photograph, therefore, is an imprint of an empirical object or event that focuses attention on what once was, but no longer is. The notion of the indexical, as a sign that represents a world that can only be rendered in the past tense, is everpresent in Ennadre's art. His photographs, which are by nature indexical, actually provide examples of the index and its relationship to the past, to loss, and to memory. A 1990 series depicting the cave paintings of Lascaux, for example, intersects with the indexical in a subtle but compelling way. Among the assorted renderings of pre-historic animals on the cavern walls can be found the impressions of human hands that signify, through absolute physical contiguity, the presence of an 'author' at the very birth of art.

In the series 'The Exhumed Dead of Vesuvius' 1985-90, Ennadre engages the indexical to represent death at its most sudden and ruthless. During archeological excavations in and around Pompeii, he photographed the bodies of victims who had been covered by volcanic ash and cinders when Vesuvius erupted in AD 79. Forever frozen in positions of terror, these petrified figures physically reference the moment of their death. They have become indexes of their own execution. Ever intrigued by that fragile border separating life from death, Ennadre, in 1991, made a series entitled 'Paleontological Vestiges', in which he photographed fossilised remains of ancient creatures.[8] The artist again invokes the indexical (in this case, primordial imprints of once living things) to signify absence. The effect of such work is far from melancholy, however. Ennadre's photographs portray the index in its various forms to extol the transitory, to acknowledge the power of time, and to demystify that irreversible passage between life and death as we know it.

Notes

1 In his discussion of the slaughterhouse series in an article on Ennadre, Francois Aubral notes that the artist projected his own 'self-portrait' into one of the images by emphasising the schematic outline of a face on a carcass. See Aubral, 'Black Light', trans Daniel W Smith, unpublished English translation of 'Lumières noires', in *Dèjá-vu*, Tokyo, 1993. Page references in this essay are from the English text. When asked about the autobiographical aspect of his work, Ennadre responded that it is present throughout, as is the case with all artistic work to some degree. He described the self-portrait as having a humorous aspect and explained that 'when there is less of a resemblance, the least sense of a human presence, then I am most present'. Correspondence with the author, 26 June , 1995.
2 Quoted from Aubral, 'Black Light', p 1.
3 Definition from *The American Heritage Dictionary of the English Language*, ed William Morris, Boston, 1979. The French term *silhouette* is ultimately derived from Etienne de Silhouette (1709-62), 'with reference to his evanescent career (March-November 1759) as French controller-general'. I would like to thank Jon Ippolito for bringing this definition and its applicability to the work of Ennadre to my attention.
4 Susan Sontag, *On Photography*, New York, 1978, p 15.
5 See Roland Barthes, *Camera Lucida: Reflections on Photography*, trans Richard Howard, New York, 1981, pp 63-119.
6 Aubral, 'Black Light', pp 4-5.
7 For an illuminating discussion of photography's relationship to the indexical, see Philippe Dubois, *L'acte photographique*, Paris and Brussels, 1983.
8 Aubral articulates the overwhelming presence of death as a subject in Ennadre's work as follows:
 'What fascinates Ennadre is the passage, the limit-point, the moment of truth in which death is already there and life has just ceased to be. He does everything to eternalise this moment, to extract its quintessence...to guard its memory, in an intention of life'.
Aubral, 'Black Light', p 18. In conversation with the author (6 July 1995), Ennadre noted that the series devoted to paleontology (with its clearly indexical tenor) is the 'ur-text' to his entire oeuvre, even though it was completed well after a number of earlier works.

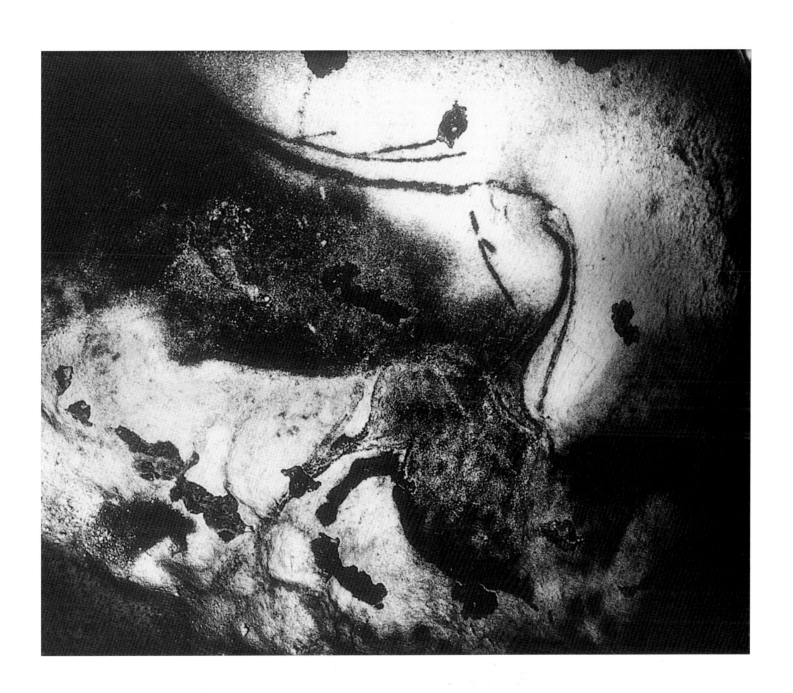

p30-31
Fish and Octopuses 1992-3

p32-33
Trance 1993-5

p 34
Auschwitz 1992

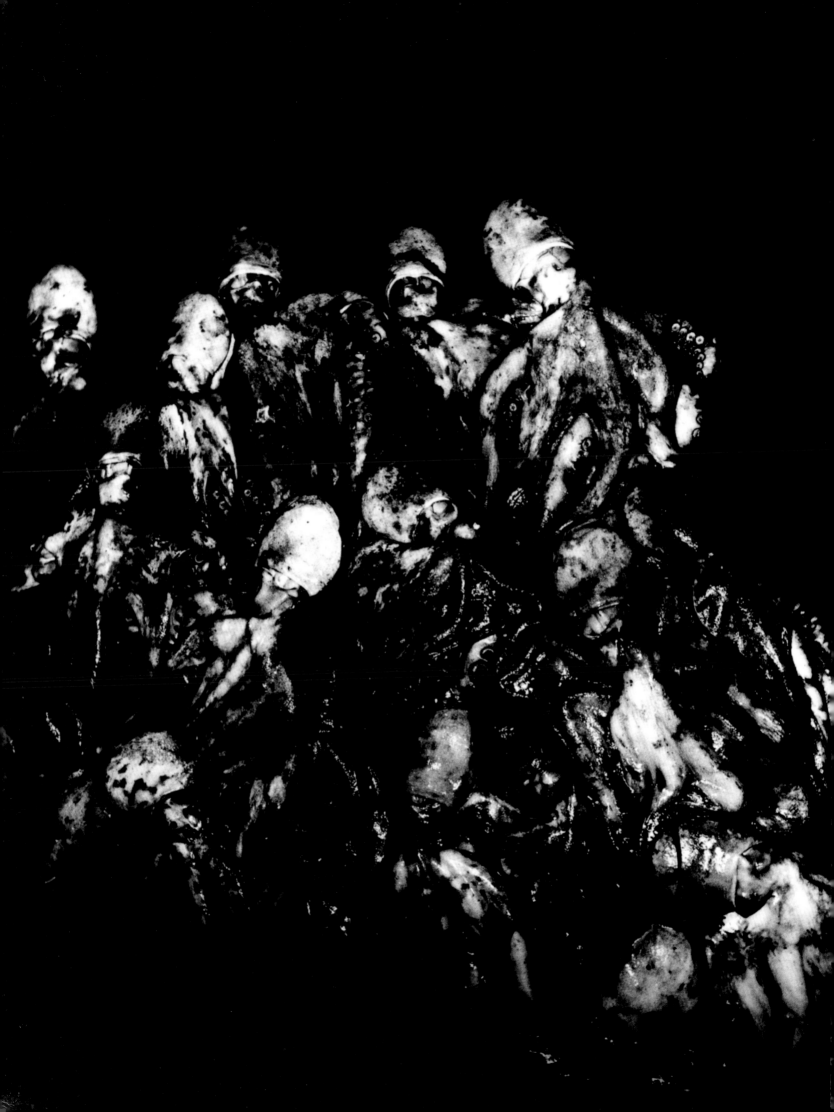

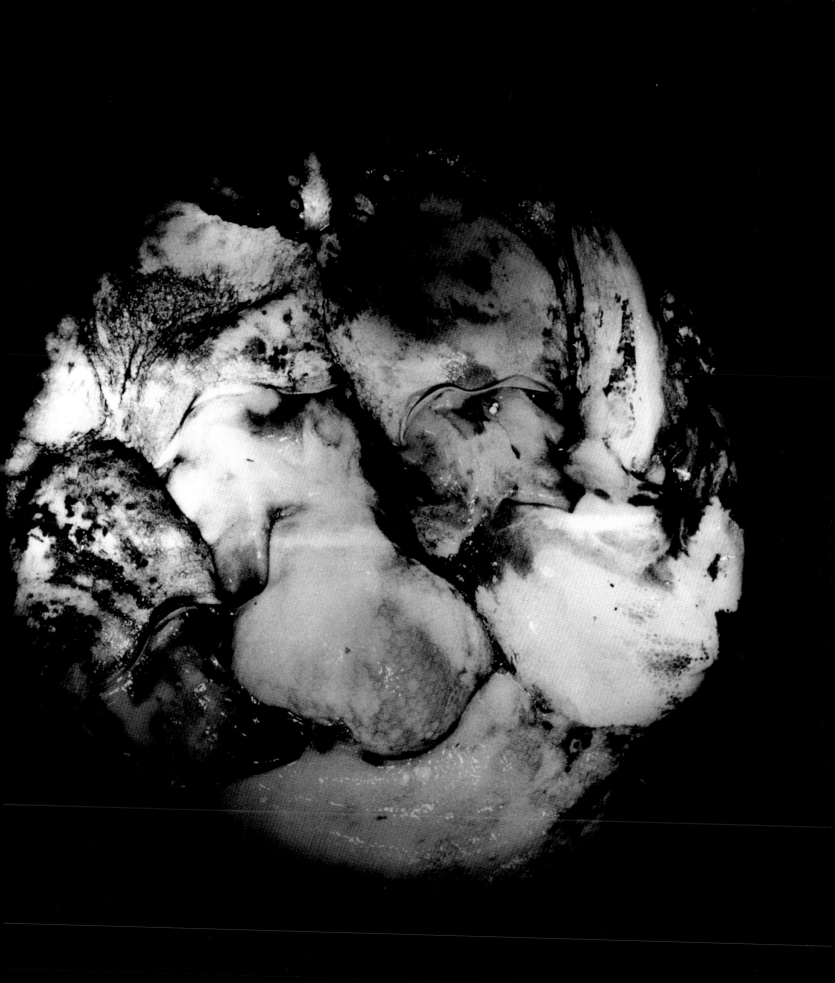

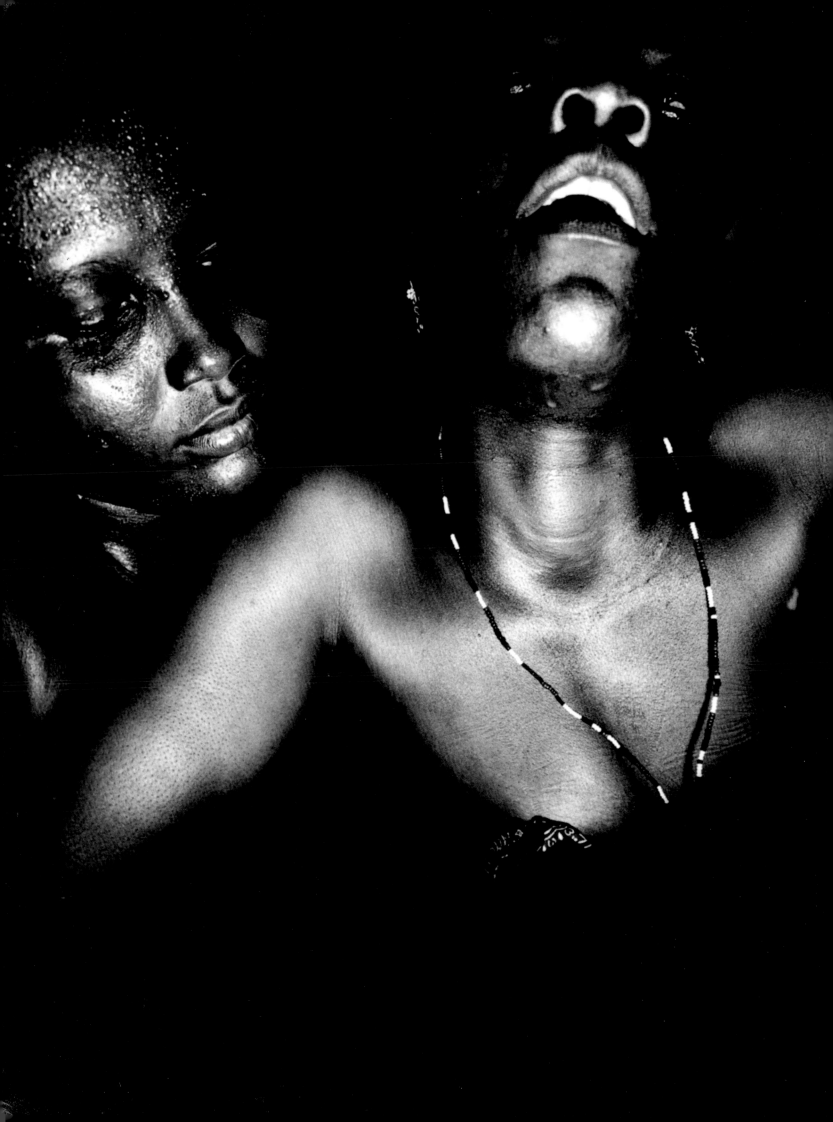

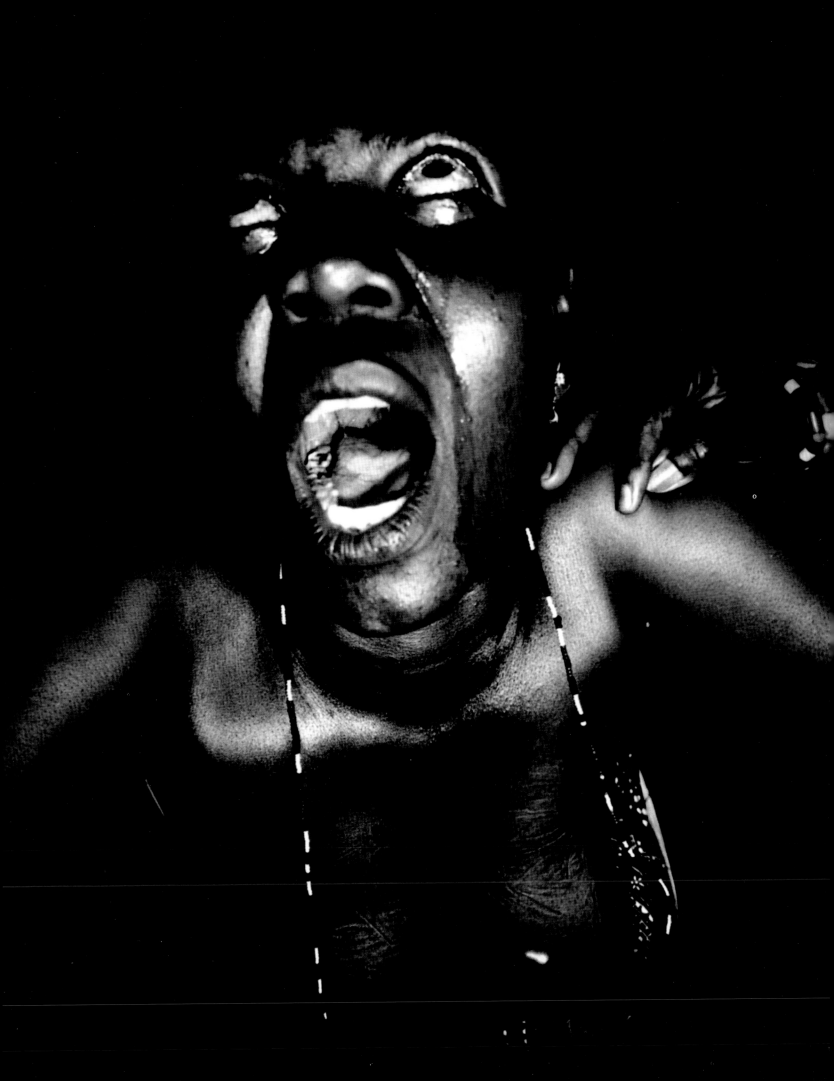

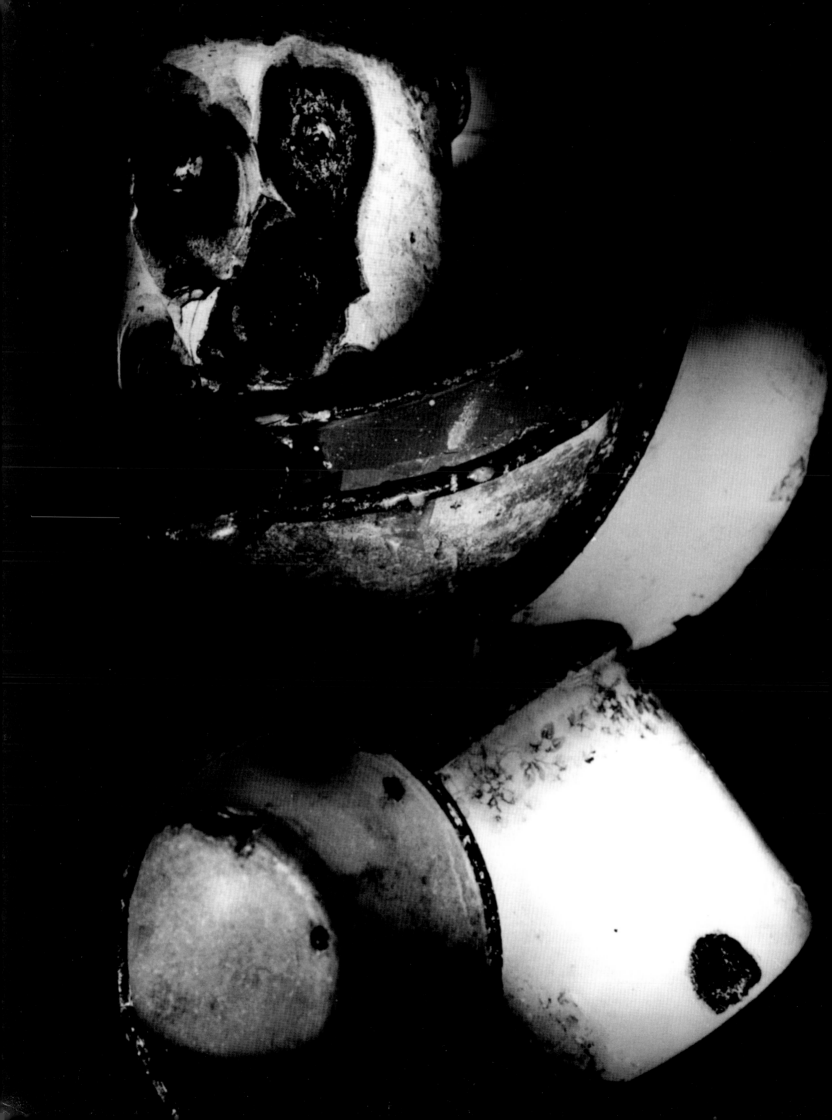

TOUHAMI ENNADRE

Biography

1953	Born Casablanca
1961	Moved to Paris
1975	Becomes photographer
1976	Travels to Morocco and New York
1976-82	Travels to Indonesia, Singapore, Malaysia, Thailand, Burma, Nepal, India, Scandanavia, Spain, Portugal
1978-82	Several residencies and exhibitions at the Cité Internationale des arts, Paris
1982-5	Travels to USA, Canada, Germany, Morocco, Italy and Sicily
1985	Residency at Villa Arson, Centre national d'art contemporain, Nice
1986	Becomes French citizen
1986-95	Travels to Italy, Sicily, Portugal, Germany, Spain, New York, Japan, Morocco, Switzerland, Austria, Benin, Haiti

Solo Exhibitions

1977	Photo Gallery, Pisa
1984	Cité Internationale des arts, Paris
1985	*Présence artistique du Maroc*, Maison de la culture, Grenoble
	Photographies du corps humain, Musée Favre, Montpellier
	Galerie K Sachs, Munich
1986	*La mort vive*, Galerie Michèle Chomette, Paris
1987	Galerie l'Atelier, Rabat
	Galerie K Sachs, Munich
1990	*Touhami Ennadre* (retrospective), Institut du Monde Arabe, Paris
1991	Institut Français, Athens
1993	Notre Dame de Paris, FNAC and Caisse Nationale des Monuments Historiques et des Sites, Fnac-forum, Paris
1993	*Tregor's festival of photography*, Lannion
1994	Exit Art, New York

Selected Group Exhibitions

1977	*Tendances actuelles de la photographie en France*, ARC - Musèe d'Art Moderne de la Ville de Paris, Paris
1985	*Das Akfoto*, Museum Moderner Kunst, Vienna; Kunstverein, Frankfurt; Museum für Kunst und Kulturgeschichte der Stadt, Dortmund
	Regards sur la villa Arson, Centre national d'art contemporain, Nice
	Intensitès nomades, Musèe Fabre, Montpellier
1987	*Young European Photographers/87*, Frankfurter Kunstverein, Frankfurt
1988	*Splendeurs et misères du corps*, Museum für Kunst und Geschichte, Fribourg; Musèe d'Art Moderne de la ville de Paris, Paris
1989	*Photographie en libertè, la photographie française*, Fondation Gulbenkian, Lisbon; Kunstverein, Frankfurt
1992	*In vitro*, Fondaçion Joan Miró, Barcelona
	Traces, Musée d'Angoulème, Angoulème
	Trans-voices, multimedia project, American Center, Paris and Whitney Museum, New York; posters exhibited in New York and Paris underground stations and Centre Pompidou, Paris
1993	Das Kunst Haus, Munich
1994	*Le corps en scène*, Institut Français de Madrid, Madrid
1995	*VITAL: Three contemporary African artists*, Tate Gallery Liverpool, Liverpool

Bibliography

Tendances actuelles de la photographie en France, Musée d'art moderne de la ville de Paris, ARC, Paris, 1977
Présence artistique au Maroc, Maison de la Culture, Grenoble, 1985
Photographie du corps humain, Journées Internationales de Montpellier, Montpellier, 1985
Intensités Nomades, Musée Fabre, Montpellier, 1986
Memoires de l'origine, des photographes en Mediterrannée, Centre de la Vieille Charité, Marseille, 1987
Young European Photographers / '87, Frankfurter Kunstverein, Frankfurt, 1987
Collection Arab du Musée d'art Contemporain, Institut du Monde Arab, Paris, 1987
Touhami Ennadre, Institut Français, Athens, 1990
Notre-Dame de Paris, text by Alain Jouffroy, photographs by Touhami Ennadre, Caisse des Monuments Historiques et des Sites, Paris, 1992
VITAL: Three contemporary African artists, Tate Gallery Liverpool, Liverpool, 1995

List Of Works

The Hands, the Back, the Feet 1978-82
black and white photographs
triptych, each panel 182.8 x 152.4 cm

'Deliveries' 1982
black and white photographs
triptych, each panel 182.8 x 152.4 cm

'The Slaughterhouses' 1983-5
black and white photographs
two panels, each 182.8 x 152.4 cm

'The Exhumed Dead of Vesuvius' 1985-1990
black and white photographs
triptych, each panel 182.8 x 152.4 cm

The Lascaux Frescoes 1990
black and white photograph
182.8 x 152.4 cm

Auschwitz 1992
black and white photograph
182.8 x 152.4 cm

Fish and Octopuses 1992-3
black and white photographs
triptych, each panel 182.8 x 152.4 cm

Trance 1993/5
black and white photographs
triptych, each panel 182.8 x 152.4 cm

All works are the collection of the artist

CYPRIEN TOKOUDAGBA

THE LINK BETWEEN EARTH AND SKY
PHILIP SWEENEY

Tokoudagba, Cyprien, Abomey, Benin. Thus, since he first added painting on canvas to his previously mural and statuary work in 1989, has Cyprien Tokoudagba signed his work, and, the current intellectual climate in favour of a modern non-primitivist appreciation of African art notwithstanding, it would be hard to imagine, for European minds, a more darkly exotic appellation. Abomey, the capital of the old kingdom of Dahomey, epicentre of the Slave Coast, was evoked for an Anglophone public most recently by Bruce Chatwin in *The Viceroy of Ouidah*. Chatwin's slave-dealing Brazilian central character is chained hand and foot when he first sees the nineteenth century Abomey of King Guézo, and marvels at the fresh-cut heads festooning the town, the palace walls of blood and clay, the three thousand strong female praetorian guard (the Amazons) and the King reclining on a velvet bolster in front of his prostrated subjects. Chatwin's fascinated vision fits more or less with the reports of Victorian predecessors such as the explorer Sir Richard Burton, who also dwelt on the mass human sacrifice of the 'Great Customs' and the vast size of the palace complexes.

The French, who ruled the country still known as Dahomey until independence in 1960 and who now go there in significant numbers as tourists, probably have a more up to date impression. It was under French administration, when Paris-educated Beninois were in demand throughout the region as cadres, that the country became known as the *Quartier Latin* of West Africa. (The main thoroughfare of the capital Cotonou is actually called Boulevard St. Michel). Nowadays, after one of the most successful and most surprising of the recent crop of African democratisations terminated nineteen years of fruitless Marxist-Leninist military rule, Benin is sometimes referred to as the Czechoslovakia of West Africa. The government of Nicephore Soglo spends its time negotiating a tortuous path between the economic privation following recent devaluation of the CFA Franc and the diplomatic exigencies of its big, rich neighbour and oil supplier, Nigeria, whose persecuted democratic dissidents use Benin as refuge and escape route.

Culturally, Benin, former Dahomey, has a particular global claim to fame as the progenitor of voodoo. It was in the territory of the Fon tribe of Dahomey that the system of cosmology, pharmacy, geomancy and practical self-help connected with *vodoun* was developed, and through the conduit of slavery to the Caribbean that this transmuted into voodoo in Haiti and the Southern USA. Though Haiti and its 'voodoo' are the best known of the Caribbean Afro-cults, vodoun and its trans-Atlantic cousins are much more widespread. While the religion of the Fon of Dahomey/Benin dominated Haiti, the very similar cults of the Yoruba in adjacent areas of Benin and what is now Nigeria, gave rise across the ocean to *santeria* in Cuba, shango cults in Trinidad and *candomblé* in Brazil, among many others.

Practitioners of Fon religion worship a series of deities known as vodoun, varying in number, name and characteristics from community to community, but with a dozen or so central figures common to all. The vodoun act as intermediaries to a vaguer supreme deity, represented in Fon religion as the masculine-feminine duality Mawu-Lisa. History, myth and symbolism mix in the character of the vodoun, who may be deified versions of actual past kings or important ancestors, personifications of natural elements or forces such as water, thunder, or illness. They may be animal-gods, progeny of the mythical union of other vodoun, or complex bundles of all of these. Whatever, each vodoun has its own personality, colours, days of the week, favourite foods, dances and drum rhythms.

Humans, royalty and commoners, individually and in families, attach themselves to particular vodoun or groups of vodoun on the strength of an affinity of character or a successful record in obtaining divine help with worldly affairs. The pantheon of vodoun has changed over the centuries as new gods come into existence and old ones fall into disuse. King Guézo, for example, identified strongly with the vodoun Dan, whose image is a circular snake, the body composed of a rainbow with its tail in its mouth, representing prosperity, continuity, and the link between earth and sky, at a time when the vodoun cults were more focused on the kings but also less standardised. With the termination of royal rule in 1900, when the French removed the last effective king, Agoli-Agba, a standardised central group of vodoun began to emerge,

prominent among them Hevioso, the god of thunder, Sagbata, god of the earth and inflicter of smallpox (to whom the sacred forest of Ganlozoum near Abomey is dedicated) and, above all, Legba. Images of Legba, trickster, messenger, watchman, the god of markets, rude, vain, cunning and phallic, are ubiquitous in Abomey, ranging from little priapic clay mound fetishes at street corners (placed in houses and by fields to ward off evil), to the powerful seated male figures, always with exaggerated phallus. Reflecting vodoun reality, Tokoudagba's work features Legba prominently.

Vodoun worship varies from the most casual of invocations for occasional help or protection, to total devotion to an individual deity, who imposes strict obligations, rules as to what the devotee may eat, etc. *Vodounsi*, vodoun adepts, follow a lengthy period of seclusion and study attached to a vodoun priest, during which their personal vodoun is divined by the system of thrown amulets known as the *Fa*. Finally, head shaven and anointed with the blood of a sacrificial animal or bird, the vodounsi becomes an initiate, able to enter trance in the drum-led ceremonies in vodoun temples or sacred groves, and be possessed or 'mounted' by his or her particular vodoun.

Tokoudagba, like his parents, is a vodounsi. The family worships six vodoun; among them Dan, Sagbata, Gou, the god of iron, and Tohossuo, the water god whose black and red colours, often in patterns of dashes (known as *damimi*) or circles *(oungêde)* recur in Tokoudagba's murals and canvases. Born in 1939 in Abomey to an artisan family, his father was a weaver, therefore of modest means, though the artist claims his ancestors were important royal officials: his great-grandfather, in particular, was a minister of King Guezo. Tokoudagba's schooling ceased after primary level, by which time he had shown quite clearly where his future lay: 'At school, all I could do was draw, and the teacher often praised me and paid me compliments. It's a gift I had. I could do whatever I wanted with my hands. Already, as a young child, I was earning money with my paintings'.

Cyprien Tokoudagba's earliest work, after a spell in the army, consisted of decoration of the walls of the vodoun temple in the compound of his own family home. The subjects, then as now, were representations of vodoun, their characteristic patterns and colours, their symbols, and, from time to time, popular sayings or historical scenes, like the beheading of the miscreant Yahazé in the reign of the seventeenth century King Akaba, which transferred in 1990 from a Tokoudagba home mural to one of his early canvases. The home murals led to commissions, first from other private individuals and then from municipal and state bodies. 'The fetishers (vodoun priests) saw the paintings and they appreciated them greatly. Since then, people from all over the place have asked me to do paintings', says Tokoudagba. Painting to order (the level of finesse and detail of his work varies according to the fee available) Cyprien Tokoudagba thus began to dominate with his imagination the low banco walls of the corrugated iron-roofed houses lining the dirt alleys of the old quarter of Abomey.

Cyprien Tokoudagba's first major public employment was in the restoration and redecoration of the palace of King Guézo in Abomey. The Guézo palace and the adjacent palace of Guézo's successor, Glélé, are the only survivors of the great complex of twelve interconnected palaces, the rest of which only exist as mud ruins half hidden by vegetation. The palaces were then being prepared for the 1989 centenary of the death of Glélé, which was marked by ceremonies led by Dah Joseph Langanfin Glélé, the president of the Council of Administration of the Royal Families of Abomey, and attended by other vestigial representatives of the great kingdoms of West Africa - the Yoruba sovereigns of Oyo, in Nigeria, Abomey's old rival, and of nearby Ketou, in Benin. After completing the restoration of the bas-reliefs of the Guézo palace, Tokoudagba worked on other parts of the Abomey Museum, where he was employed as restorer in 1987. The frescoes of the museum, which is Benin's oldest and richest in holdings, are his work, as is the decoration of the museum restaurant.

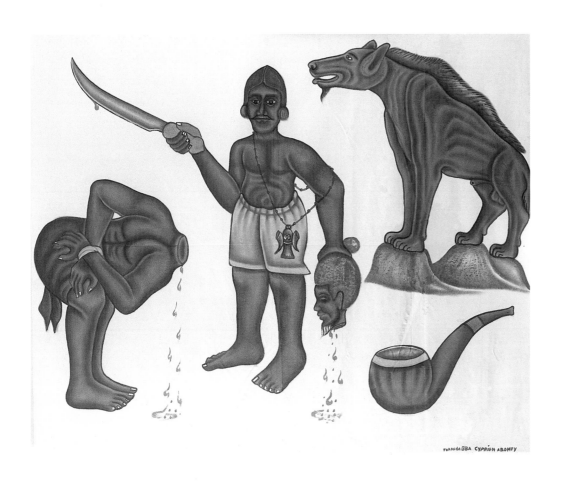

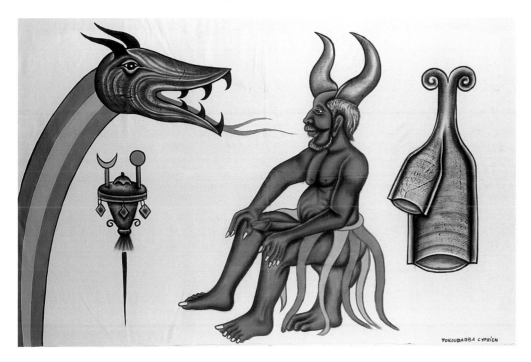

In 1987, Tokoudagba's international exposure began, with a visit from Jean-Hubert Martin, curator of the immensely influential 1989 Paris exhibition *Magiciens de la Terre*, and his colleague, André Magnin. Invited to Paris with his wife, Valerie, who helps with his three-dimensional works, Tokoudagba created murals for a replica Abomey house and constructed his celebrated statuary group of the seated Zangbéto-lègba, surrounded by totemic animals and confronting a prostrate supplicant. Paris was a revelation to Tokoudagba. 'It was great to meet other artists and to see what they were doing... It helped sharpen my mind, it developed my imagination, it also gave me lots of ideas about what to do from a creative point of view'. It was in Paris that Tokoudagba produced his first painting on plywood, 'The Emblem of King Kpingla', as a gift, and on his return to Benin, he began to use acrylic on canvas, a development which has since enabled him to contribute to half a dozen international exhibitions.

In relation both to his earlier works, and to those of other Beninois muralists, Tokoudagba's painting has changed and developed. His use of a shadow effect adds three dimensional detail to some subjects, while he has taken to the occasional use of live models to achieve greater realism. His subject matter remains centred on vodoun and Dahomean history, but also draws on related fields. An exhaustive analysis of his symbolism for the outside world has yet to be undertaken, and in any case may not be ultimately possible, as vodoun lore beyond a certain level is reserved for initiates. 'Nothing is written down; everything is transmitted orally. Once you have entered, you cannot go back on your decision. You have to resist all temptation. It is the quality of his knowledge that gives the fetisher his power. These secrets must never be divulged unless you yourself become a priest and someone comes to you to be initiated', says Tokoudagba. This applies equally to the secret societies, such as the Zangan and Zangbéto, which have also acted as patrons and sources of material for the artist. The Zangbéto (night hunters), whose Legba statue, adorned with the society's horned regalia, is a central Tokoudagba image, is a sort of relaxed semi-folkloric version of other, more feared West African male secret societies like the Oro, the appearance of whose costumed masked members on the streets at night

would have the population cowering behind barred doors.

In addition to the divine, human and animal characters in Tokoudagba's paintings are individual human parts, especially legs, calling to mind the Fon *aziza*, one-armed, one-legged forest spirits (not to mention the Abomey palace bas-relief depicting King Guézo's imaginative punishment for an offending messenger, pounding the unfortunate man's head in a mortar, with his own leg as a pestle). The inanimate contents of the pictures require as much decoding. They range from ceremonial gongs, bells and drums, through sabres, pipes, the royal batons which represented a king, to *asin*, portable altars atop iron spikes in which groups of symbolic objects associated with a prominent person's life are used to honour him in death.

Cyprien Tokoudagba's burgeoning reputation abroad has of course enhanced his standing at home; his set of monumental sculptures was prominent among the exhibits at Ouidah 92, Benin's 'first world voodoo arts and culture festival' which took place, in fact, in 1993, attended by delegates from across the Afro-American world. It is worth noting, incidentally, that the work of Tokoudagba and his confrères speaks to a much larger, directly involved audience, beyond Benin. The world of Afro-based religion is astir, with new white converts, re-groupings and attempts to re-establish old hierarchies, led by Africa, on an international basis. I recently attended an Afro-American cult conference in Brazil, organised by white Argentinean businessmen, at which the King of Ketou, next door to Abomey, was honoured guest. In decades to come, might it be too fanciful to see Cyprien Tokoudagba's paintings as key images of new voodoo Vatican?

All quotations from the artist are from an interview between Tokoudagba and André Magnin, to be published in the catalogue of a forthcoming solo exhibition at Ifa-Galerie, Bonn/Stuttgart, 1995.
Thanks to André Magnin for use of this transcript.

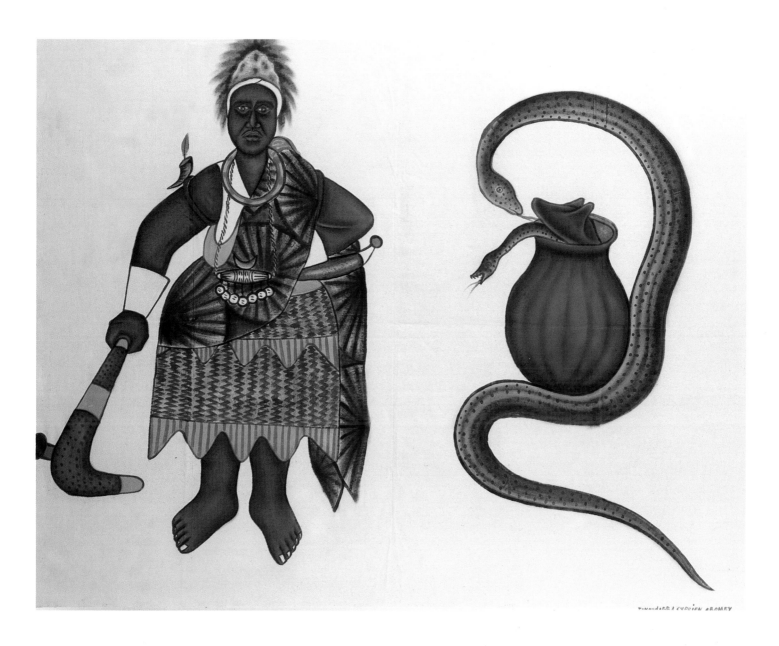

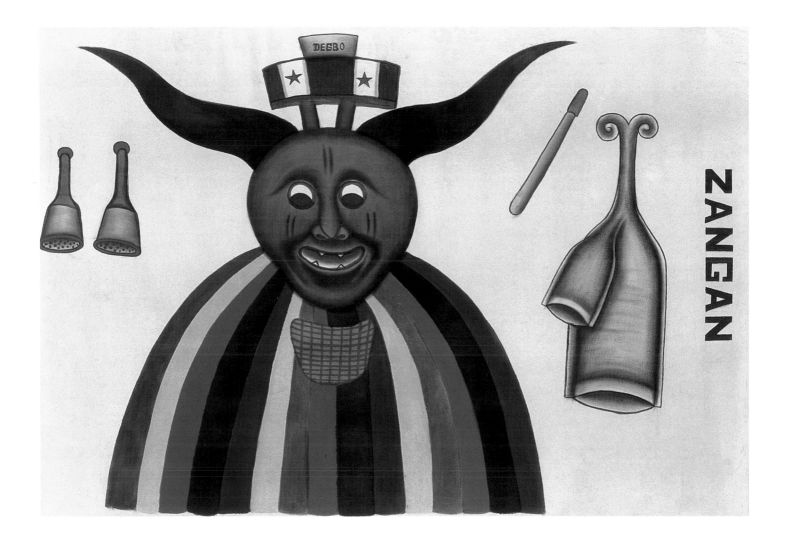

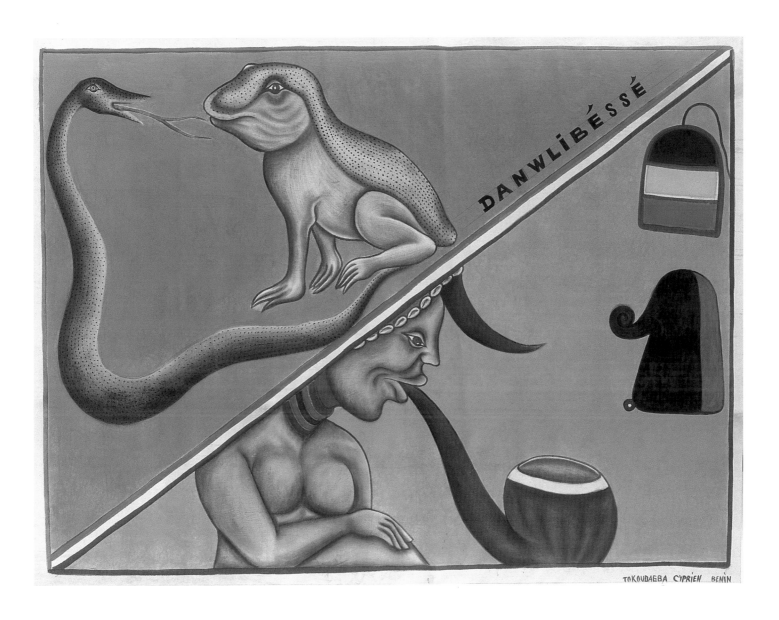

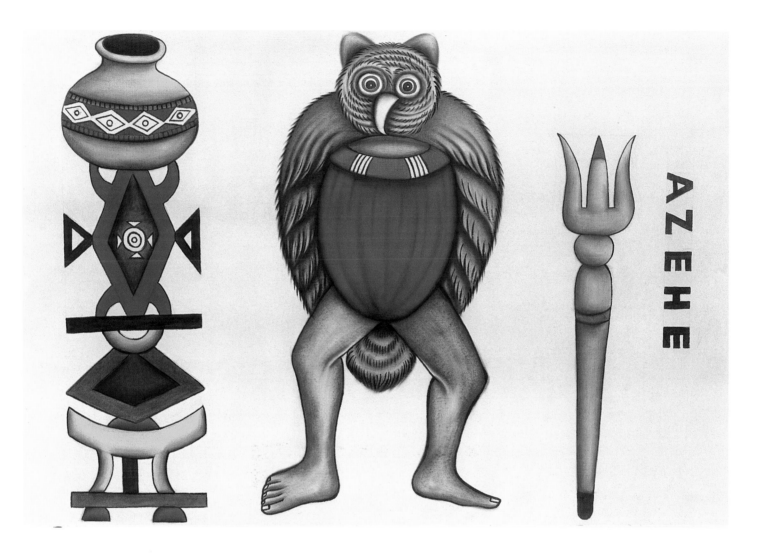

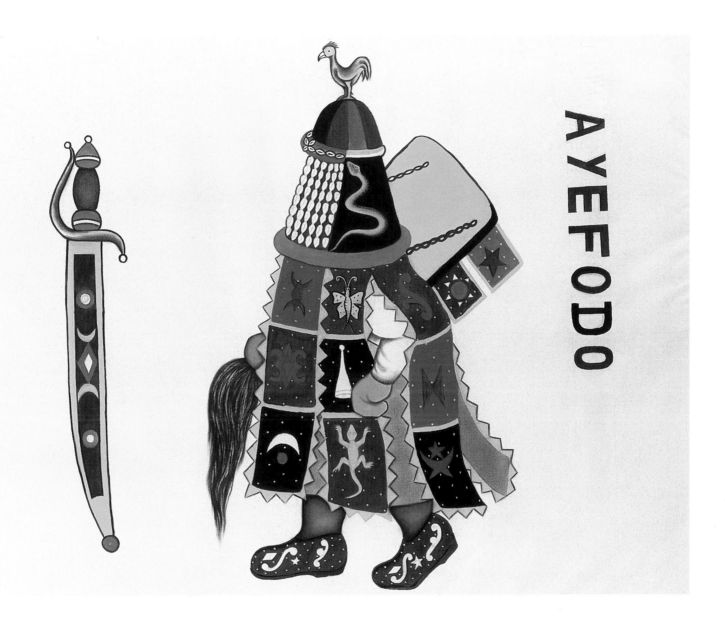

AYEFODO

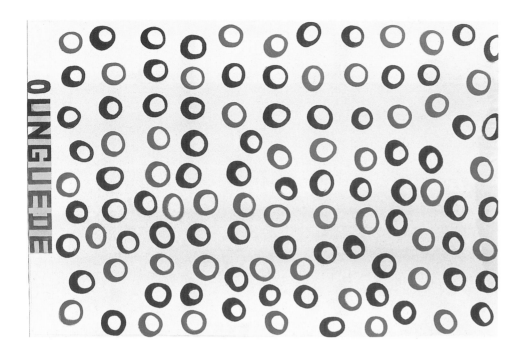

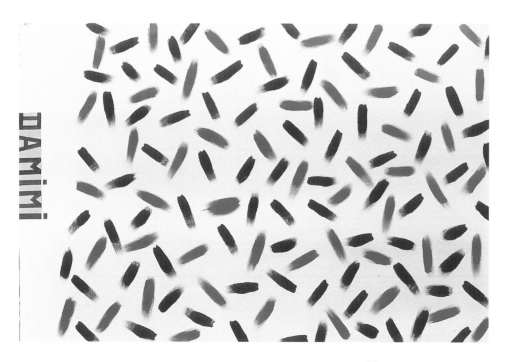

CYPRIEN TOKOUDAGBA

Biography

1939	Born Abomey, Benin
	Initiated into *vodoun* at an early age
1960	Begins working as an artist, in terracotta,
	then in cement and sand
1987	Begins work as a restorer at the museum of Abomey
1989	Leaves Benin for the first time to participate in
	Magiciens de la Terre exhibition, Centre Georges
	Pompidou, Paris

Solo exhibitions

1991	Centre Culturel Français de Cotonou, Cotonou, Benin
1995	Ifa-Galerie, Bonn; travels to Ifa-Galerie, Stuttgart
1995	Musée du Cloître - Peuple et Culture Tulle, France

Group exhibitions

1989	*Magiciens de la Terre*, MNAM Centre Georges Pompidou, Paris, La Grande Halle de la Villette, Paris
1991	*Africa Hoy*, Centro Atlantico de Arte Moderno, Las Palmas de Gran Canaria, Centro Cultural de Arte Contemporaneo, Mexico City
1991	*Africa Now*, Groninger Museum, Grôningen
1991	*Ny Afrikansk Billedkunst*, Rundetarn, Copenhagen
1992	*Out of Africa*, Saatchi Collection, London
1993	*Ouidah 92*
1993	Sydney Biennale
1993	*La Grande Vérité: Les Astres Africains*, Musée des Beaux-Arts de Nantes, Nantes
1994	*Rencontres Africaines*, Institut du Monde Arabe, Paris; travelled to Johannesburg and Le Cap
1995	*The Big City*, Serpentine Gallery, London
1995	*VITAL: Three contemporary African artists*, Tate Gallery Liverpool, Liverpool, 1995

Bibliography

Magiciens de la Terre, Centre Georges Pompidou, Paris, 1989

Africa Hoy, Centro Atlantico de Arte Moderno, Las Palmas de Gran Canaria, 1991

Ny Afrikansk Billedkunst, Rundetarn, Copenhagen, 1991

Out of Africa: The Jean Pigozzi Contemporary Art Collection at the Saatchi Collection, Saatchi Collection, London, 1992

Sydney Biennale, Art Gallery of New South Wales, Sydney, 1993

Revue Noire, no 12, March-April-May, 1994, pp 16-7

Rencontres Africaines, Institut du Monde Arabe, Paris, 1994

VITAL: Three contemporary African artists, Tate Gallery Liverpool, Liverpool, 1995

List of works

Sagbata, (God of the earth) 1990
acrylic on canvas
148 x 193 cm

Scene of King Akaba - Akanbahou Yahazé sohin toto
(Akaba has killed Yohazé being bent over) 1990
acrylic on canvas
145x 178 cm

Zangbéto-lègba (with Dan, God of the rainbow) 1990
acrylic on canvas
143 x 225 cm

Daguessou (power of King Guézo) 1992
acrylic on canvas
150 x 243

Ayefodo (ghost) 1994
acrylic on canvas
138 x 180 cm

Azehe, sorcerer's bird (owl) 1994
acrylic on canvas
138 x 206 cm

Damimi (emblems of Tohoussou, God of water) 1994
acrylic on canvas
140 x 210 cm

Danwlibéssé (the serpent wants to catch the toad who
will always find a saviour) 1994
acrylic on canvas
146 x 194 cm

Oungêde (emblems of Tohoussou, God of water) 1994
acrylic on canvas
135 x 208 cm

Zangan, chief of the Zangbeta (guardian of the night) 1994
acrylic on canvas
145 x 216 cm

All works are kindly lent by C.A.A.C. - The Pigozzi Collection, Geneva

Front cover:
Farid Belkahia Hand 1980

Back cover:
Touhami Ennadre Trance 1993

Photo Credits
All Farid Belkahia photographs by Richard Goulding, Manchester
All Cyprien Tokoudagba photographs by Claude Postel

ISBN 1-85437-170-3

VITAL: Three contemporary African artists
Published to accompany the exhibition
organised by Tate Gallery Liverpool
13 September - 10 December 1995
Prepared by Tate Gallery Liverpool
Edited by Judith Nesbitt
Designed by John Rooney, Manchester
Printed by Printfine, Liverpool
Copyright © Tate Gallery, the authors and the artists 1995